First Published 2003
Redstone Press
7a St Lawrence Terrace,
London W10 5SU
www.redstonepress.co.uk

Artwork: Terence Smiyan,
and Otis Marchbank
Production: Tim Chester

© David Shrigley 2003

ISBN 1 870003 73 X

A CIP record for this book is
available from the British Library

Give this to your children when they grow up.

MOST OF THIS IS
WRITTEN IN THE FIRST
PERSON BUT SOME OF IT
ISN'T .

THIS IS ABOUT WHO I
AM AND WHAT I WANT
IT'S NOT ABOUT WHO
YOU ARE AND WHAT YOU
WANT. YOU ALWAYS
THINK EVERYTHING I
WRITE IS ABOUT YOU
BUT IT'S NOT. IT'S
ALL ABOUT ME.
SO DON'T GET UPSET
AND SAY THAT I MISUN
-DERSTAND YOU BECAUSE
IT'S NOT YOUR WORDS
I'M WRITING IT'S MINE.
I DON'T CARE ABOUT
YOU AND I DON'T CARE
WHAT YOU WANT — JUST
SHUT UP AND LISTEN.
AND I'LL LEAVE SOME
SPACE AT THE END SO
YOU CAN WRITE WHO YOU
ARE AND WHAT YOU THINK
YOU WANT

[text scribbled out and illegible]

AT TIMES I MAY
WRITE ABOUT MY FEELINGS
TOWARDS YOU AND WHAT
I THINK ABOUT YOU —
BUT DON'T GET EXCITED
IT'S STILL ~~ONLY~~ ABOUT
ME AND HOW I FEEL

—I'M JUST TRYING TO
MAKE YOU UNDERSTAND

POEM WRITTEN WHILST DRIVING:

WHO ARE YOU ?

I DON'T KNOW

WHAT DID YOU DO TODAY ?

I DID NOTHING

WHERE DO YOU LIVE ?

I LIVE IN A DITCH

I TRY TO PUSH MYSELF FORWARD EVERY DAY

FIRST I FIND A STARTING POINT
AND I START THERE.
I SELECT A BOOK FROM THE
BIG TIT LIBRARY AND I SIT
READING IT. THEN I DO MY
CHORES WHICH ARE BORING.
THEN I ASK FOR A CUP OF
TEA AND THE GIRL SAYS WHAT
STRAIN OF TEA DO I WANT?
AND I SAY BUILDERS' TEA.
THEN SHE QUESTIONS ME
ABOUT THE INDELIBLE MARKS
ON MY CLOTHES AND I SAY
IT WASN'T ME AND SHE SAYS
THAT I AM THE ULTIMATE
TORMENT.

CHAPTER ONE

WHO I Am

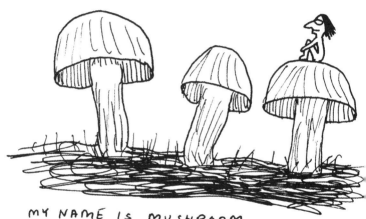

MY NAME IS MUSHROOM
MY NAME IS TOADSTOOL
MY NAME IS SPORE
MY NAME IS FUNGUS
MY NAME IS MILDEW
MY NAME IS BOG, FEN, MARSH + SWAMP
MY NAME IS TRUFFLE
MY NAME IS BACTERIA
MY NAME IS YOGHURT
BUT YOU CAN CALL ME PETE

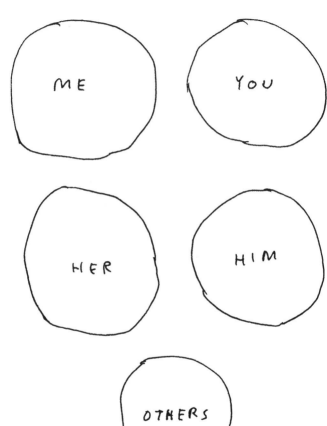

MY MOTHER WAS A VERY
BEAUTIFUL WOMAN ████ ALTHOUGH
SHE SMELT OF CATS

I SUFFERED FROM DEPRESSION
BUT THEN I GOT BETTER

MY FATHER WAS A STRONG AND
HANDSOME MAN AND I WAS
ALWAYS PROUD TO WALK BY
HIS SIDE

AS A CHILD PART OF
MY INITIATION INTO
MANHOOD WAS TO RUN
THROUGH THE WATERFALL

I WAS NOT ALWAYS AS I
AM NOW

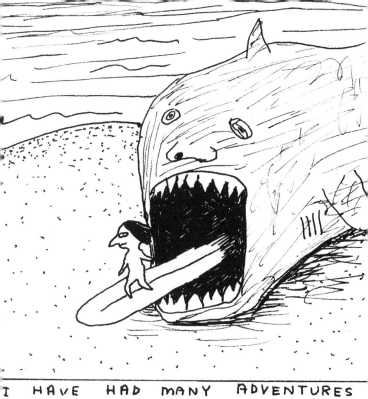

I HAVE HAD MANY ADVENTURES
AND SEEN MANY THINGS

I'M NOT ALLOWED IN THE
GOLDEN NUGGET

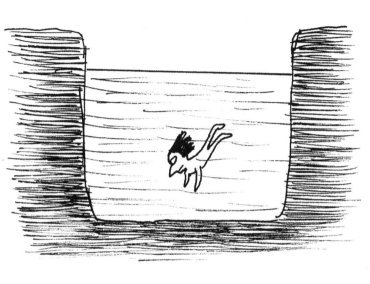

I DON'T CONSIDER MYSELF
A HEAVY DRINKER, BUT
I DO DRINK HEAVILY ON
OCCASION — PARTICULARLY
WHEN I AM SAD OR
WHEN I AM HAPPY OR
WHEN I AM BORED

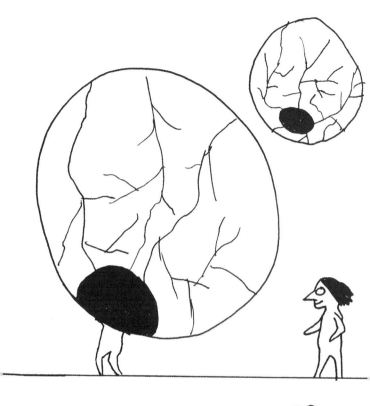

I AM A CRAZY ~~MOTHER~~
~~FUCKER~~

AND

I AM VERY PROUD OF

MY ARTISTIC ACHIEVEMENTS

I LIKE SPORT

I LIKE TO WATCH

AND I LIKE TO PARTICIPATE

I AM WITHOUT SHAME,
IT IS SAID.

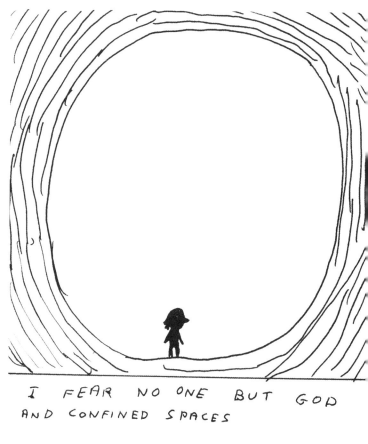

I FEAR NO ONE BUT GOD
AND CONFINED SPACES

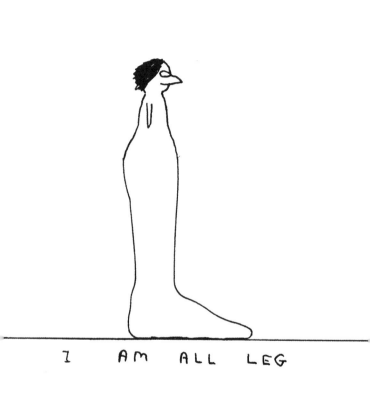

I AM ALL LEG

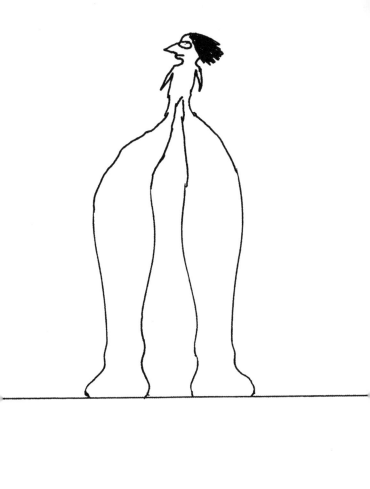

MY

MAIN

PROBLEM

MY KNEE

CRACKS

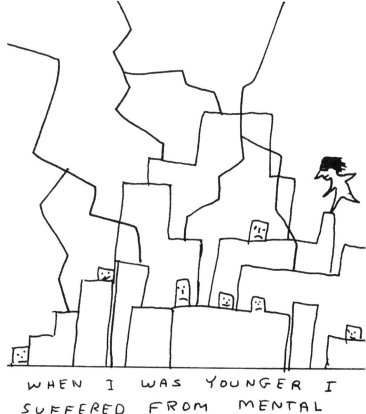

WHEN I WAS YOUNGER I
SUFFERED FROM MENTAL
ILLNESS

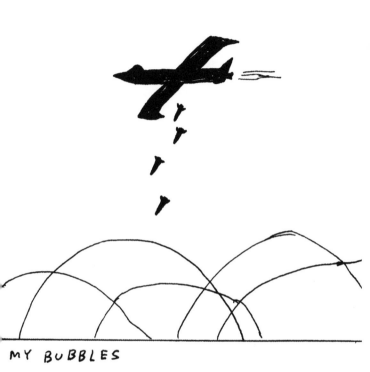

MY BUBBLES

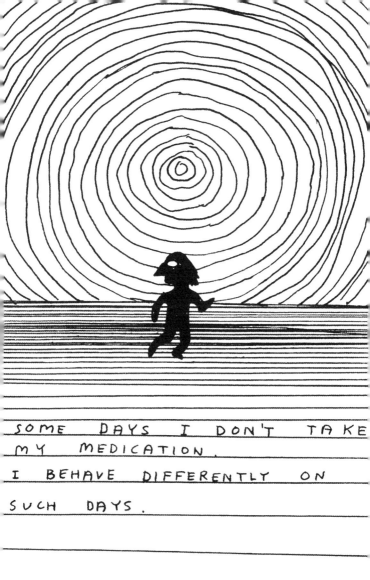

SOME DAYS I DON'T TAKE
MY MEDICATION.
I BEHAVE DIFFERENTLY ON
SUCH DAYS.

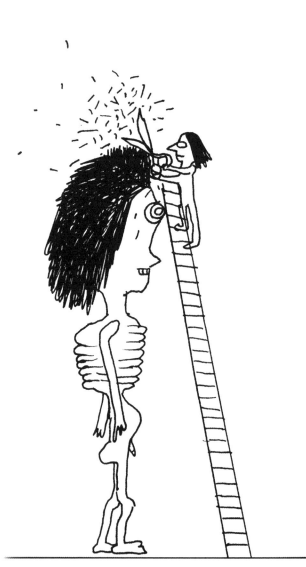

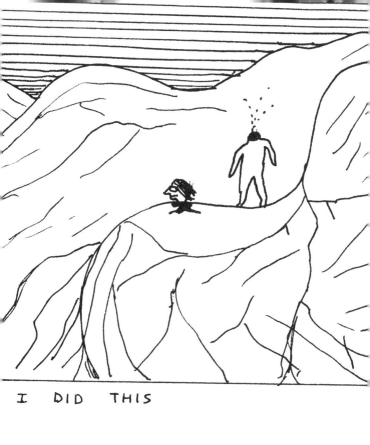

I DID THIS

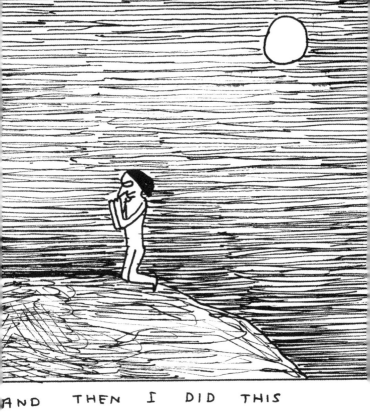

AND THEN I DID THIS

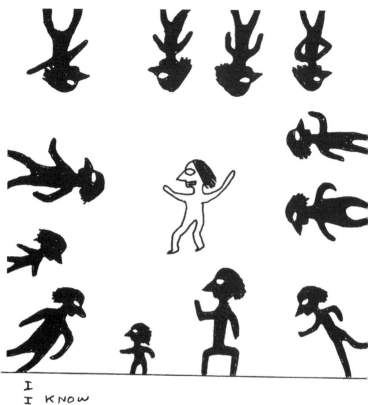

I
I KNOW
I KNOW THAT
I KNOW THAT SOME
I KNOW THAT SOME OF
I KNOW THAT SOME OF THE
I KNOW THAT SOME OF THE THINGS
I KNOW THAT SOME OF THE THINGS I
I KNOW THAT SOME OF THE THINGS I DO
ARE EVIL AND WRONG BUT I JUST
CAN'T HELP MYSELF

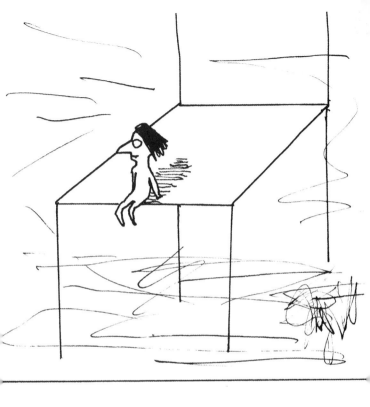

SOMETIMES I FEEL THERE'S SO
LITTLE OF ME LEFT THAT I'M
HARDLY HERE

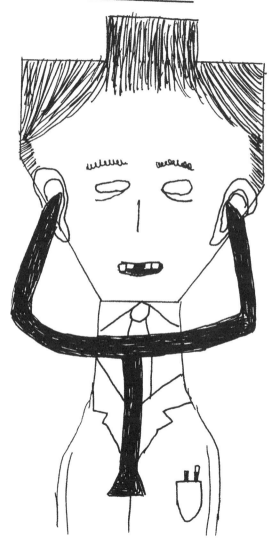

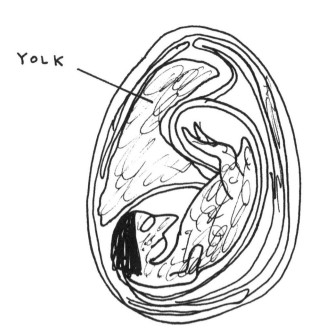

YOLK

LADY

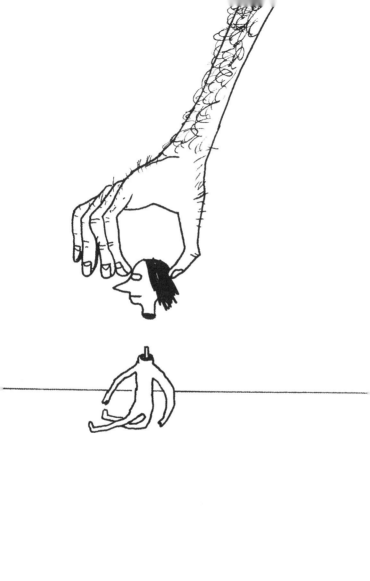

I AM PERSUED INTO THE DARKNESS
BY A SUPERNATURAL FORCE

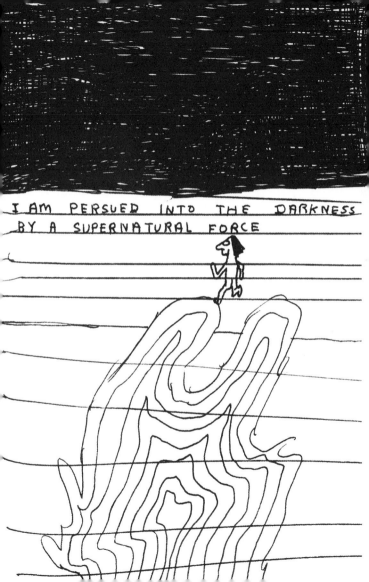

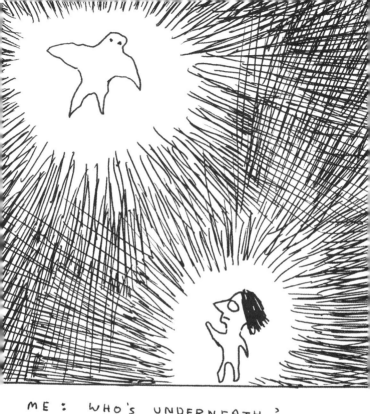

ME : WHO'S UNDERNEATH ?

SPIRIT : PEOPLE WITH NO EYES AND
FLESH LIKE THAT OF A WORM.
THEY CONTROL EVERYTHING.

ME : WHAT SHOULD I DO ?

SPIRIT : DIG THEM UP AND TRY TO
REASON WITH THEM.

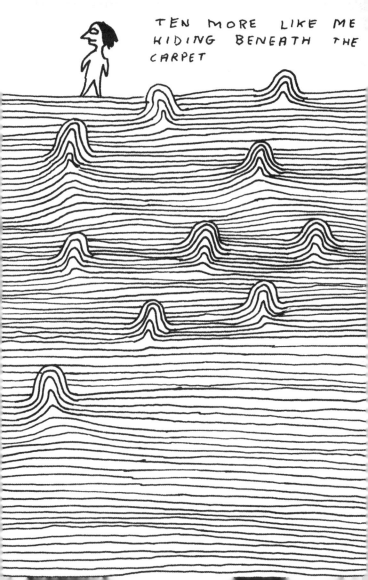

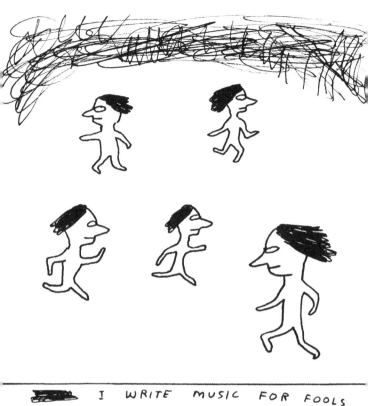

I WRITE MUSIC FOR FOOLS TO DANCE TO. THAT'S HOW I MAKE MY LIVING. IT'S OK. I WAKE UP AT NIGHT WITH THE TUNES IN MY HEAD AND I WRITE THEM DOWN. IN THE MORNING I PLAY THE TUNES ON THE MOUTH ORGAN AND I SEND A RECORDING TO THE MUSIC COMPANY I THEY PAY MONEY INTO MY BANK ACCOUNT.

I AM A KIND OF
 SANTA CLAUS

I AM A KIND OF
 TOOTH FAIRY

I AM A KIND OF
 GARDEN GNOME

I AM A KIND OF
 GAURDIAN ANGEL

I AM A KIND OF
 PIXIE, ELF OR SPRITE

I AM A KIND OF
 ~~████~~ BITING INSECT

I AM KIND OF ALL OF THESE
 POSSIBLY
THINGS AND ∧ MORE THINGS
BESIDES I THINK

I USED TO BE
8 CENTIMETRES
HIGH AND I
LIVED IN AN
ANTIQUE
FURNITURE SHOP

I USED TO EAT
WOODWORM AND
I HAD A FREIND
CALLED KEITH
WHO WAS 2 cm
TALLER THAN ME

I'M AMBIDEXTOROUS

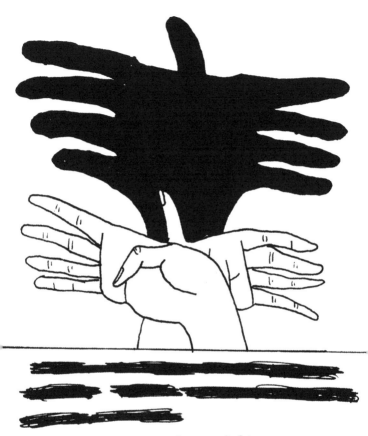

THE SUM OF MY ACHIEVEMENTS

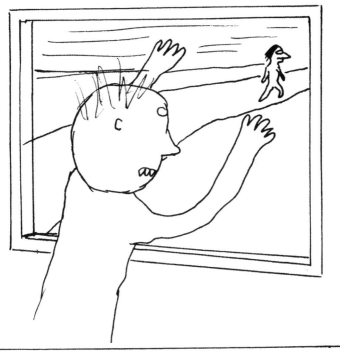

I ONCE HAD A JOB CARING
FOR THE FEEBLE-MINDED AND
~~████████████~~ WHEN
IT WAS OVER IT WAS HARD
TO LEAVE THOSE WHOM I HAD
~~████ ████~~ CARED FOR

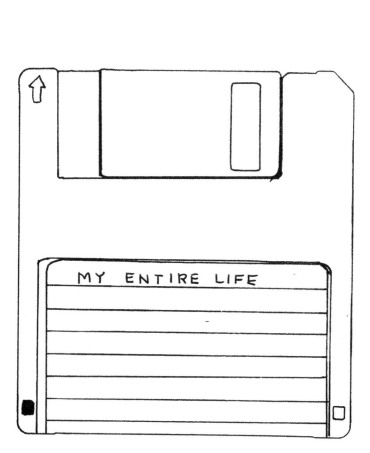

CHAPTER TWO

WHAT I WANT

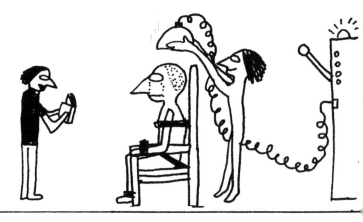

I WANT TO BE THE ONE WHO PULLS
THE SWITCH
AND I WANT TO BE THE ONE
WHO READS THE PRAYER
AND I WANT TO BE THE
ONE IN THE CHAIR
AND I WANT TO BE IN THE
AUDIENCE

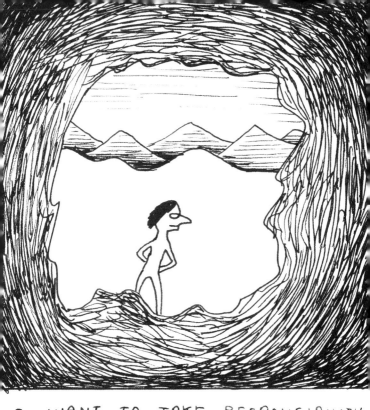

I WANT TO TAKE RESPONSIBILITY.
IN THE IMAGE ABOVE I AM
SHOWN TAKING RESPONSIBILITY
FOR SOME LOST CHILDREN.
I AM LOOKING FOR THEM IN
A CAVE.

I WANT TO BE FRIED IN
A ● PAN WITH BUTTER AND
SOME GARLIC

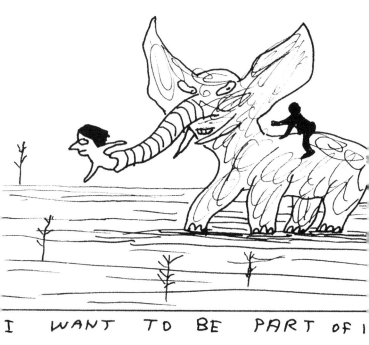

I WANT TO BE PART OF I

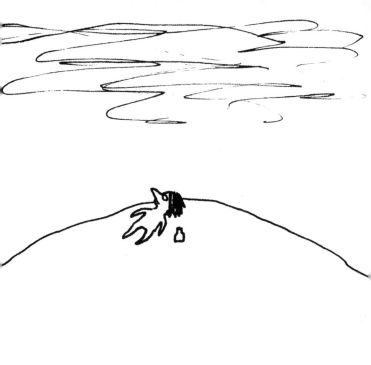

AND I ALSO WANT TO BE
NOTHING TO DO WITH IT

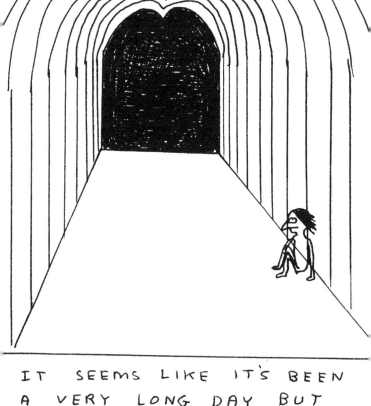

IT SEEMS LIKE IT'S BEEN
A VERY LONG DAY BUT
IT ISN'T EVEN LUNCHTIME
YET

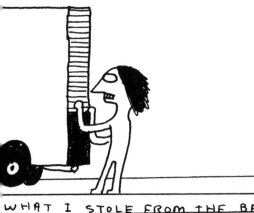

WHAT I STOLE FROM THE BACK OF THE WAGON :

A KEY

A SPOON

A C.D.

A POEM

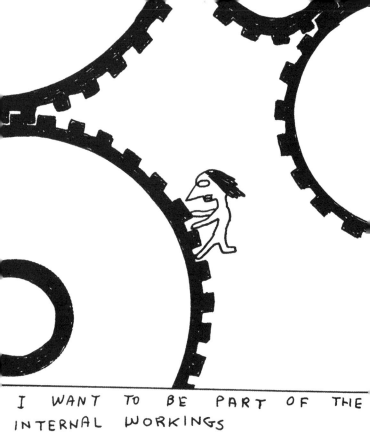

I WANT TO BE PART OF THE
INTERNAL WORKINGS

AND CRUSHED TO MUSH WITHIN
THEM

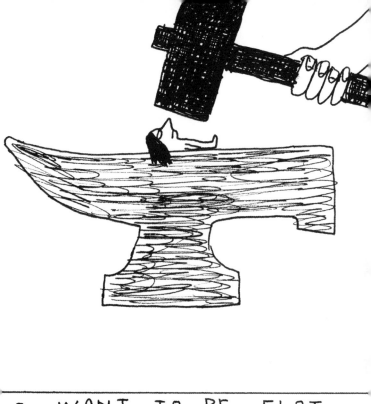

I WANT TO BE FLAT

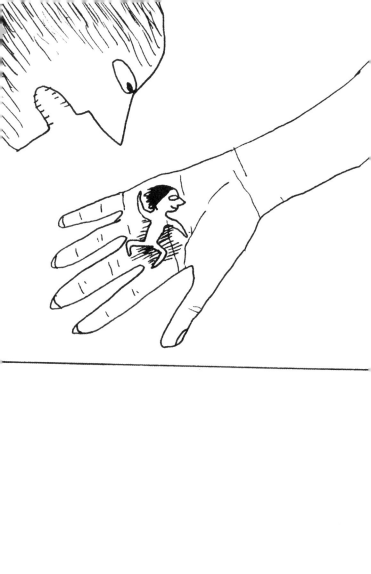

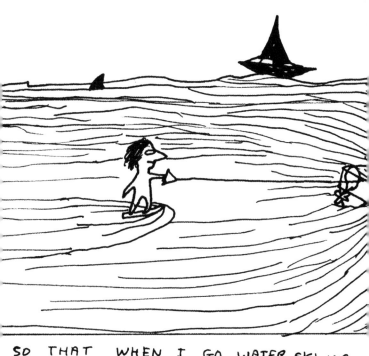

SO THAT WHEN I GO WATER SKI-ING
AND FALL OFF I WILL DISSOLVE
BEFORE THE SHARKS CAN EAT
ME

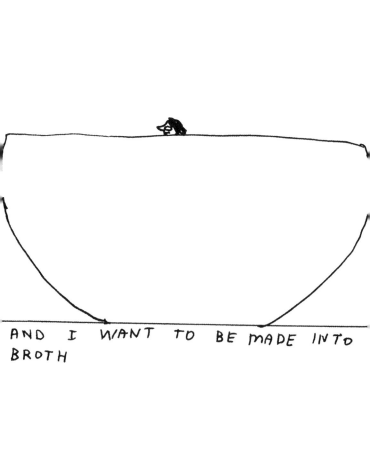

AND I WANT TO BE MADE INTO BROTH

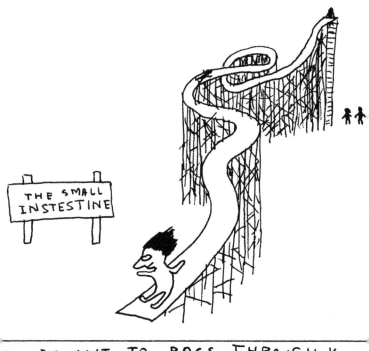

THE SMALL INSTESTINE

AND I WANT TO PASS THROUGH YOU

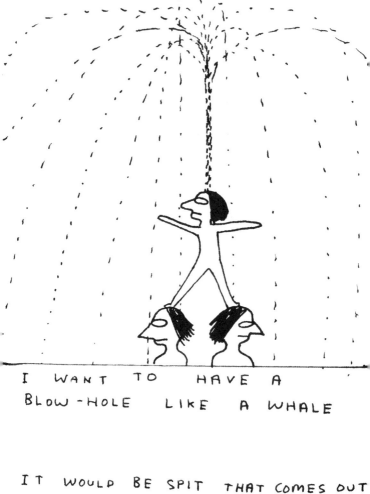

I WANT TO HAVE A
BLOW-HOLE LIKE A WHALE

IT WOULD BE SPIT THAT COMES OUT

AND I WANT TO BE RELEVENT

UHRRR G G G !

GRRRRRR !

I WANT TO WEAR THEIR FUR

MANE

I WANT TO EAT
THEIR MEAT

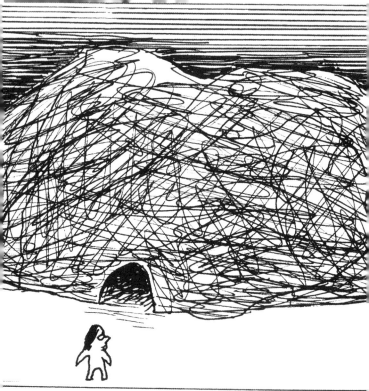

I HAVE REASON TO BELIEVE THAT
THE TROGLODITES HAVE BEEN SIFTING
THROUGH MY RUBBISH. IT IS MY
INTENTION TO CONFRONT THEM
ABOUT IT.

I WANT TO BE A CHILD AGAIN

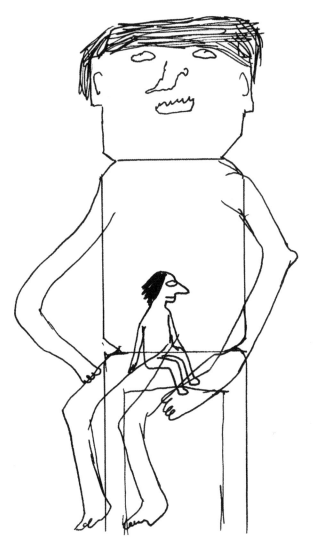

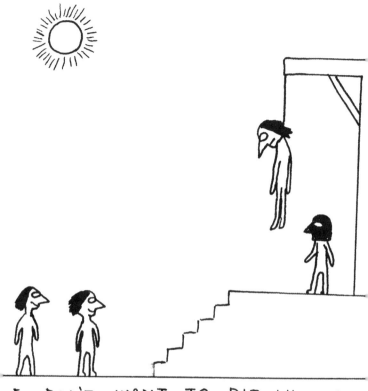

I DON'T WANT TO DIE LIKE THIS

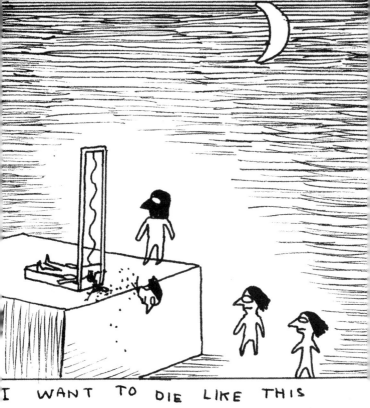

I WANT TO DIE LIKE THIS

SOMETIMES I WISH I HADN'T
BEEN BORN

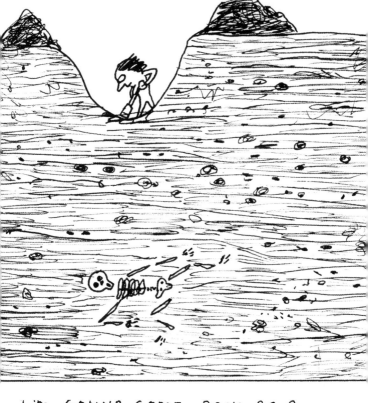

I'M GONNA COME BACK AS A
GHOST AND DIG UP MY OWN CORPSE

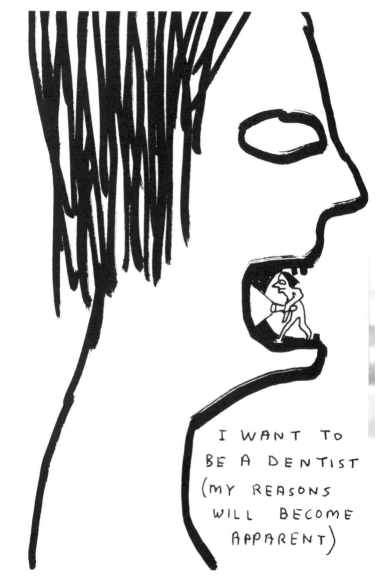

PROFILE OF THE DRILL

THE TOOTH'S HEAD

THE TOOTH'S SHELL

THE TOOTH'S GUTS

THE TOOTH'S STUFFING

THE TOOTH'S HORN

THE TOOTH'S HEART

THE STUMP OF THE TOOTH

THE TOOTH'S BONE

THE GUM LINE

THE GUM ITSELF

TO OTHER PARTS OF THE HEAD

BLOOD VEIN

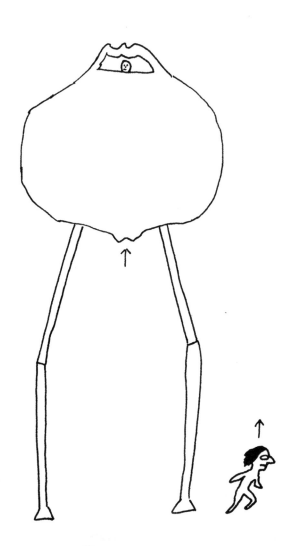

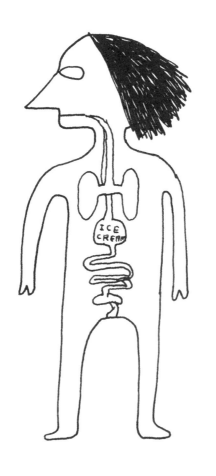

I KNOW HOW TO ENJOY MYSELF

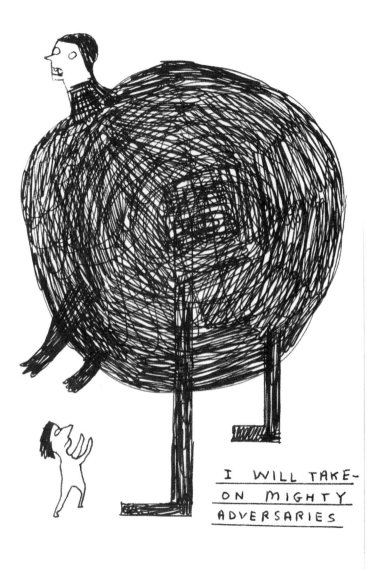

I WILL TAKE-
ON MIGHTY
ADVERSARIES

SOMETIMES I LIKE TO STAND
STILL FOR LONG PERIODS AND
THINK ABOUT THINGS

IF MY SKULL WAS FOUND BY
PRIMITIVE PEOPLES THEY WOULD
PROBABLY BE AMAZED BY IT.

IF THEY FOUND YOURS THEY WOULD
BE UNIMPRESSED AND WOULD
PROBABLY NOT EVEN PICK IT UP
OR THEY MIGHT USE IT TO KEEP THINGS
IN (PEBBLES, ETC.)

I WISH TO HEAR THE
CLANKING OF THE HUGE
STEEL BALLS

AND

I WANT TO BE A DOG

MY NAME WILL BE
'THE WEEN'

I WANT YOU TO
MAKE A FILM OF
ME SPEAKING

ALL OF THIS IS REAL
IT'S ACTUALLY HAPPENING
YOU ARE NOT IMAGINING ANY OF IT

WHEN YOU TELL A STORY YOU
SHOULD MAKE SURE THAT IT
HAS A BEGINNING, A MIDDLE
AND AN END. IF IT DOESN'T
HAVE ALL OF THESE, FOR INSTANCE
IF IT JUST HAS A MIDDLE, THEN
YOUR STORY IS NO GOOD AND YOU
SHOULDN'T TELL IT.

CHAPTER THREE

THE
MODERN MIND

A SNOWFLAKE

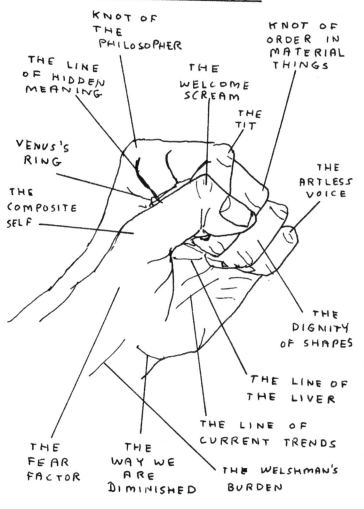

PARTS OF THE FIST

KNOT OF THE PHILOSOPHER

KNOT OF ORDER IN MATERIAL THINGS

THE LINE OF HIDDEN MEANING

THE WELCOME SCREAM

THE TIT

VENUS'S RING

THE ARTLESS VOICE

THE COMPOSITE SELF

THE DIGNITY OF SHAPES

THE LINE OF THE LIVER

THE LINE OF CURRENT TRENDS

THE FEAR FACTOR

THE WAY WE ARE DIMINISHED

THE WELSHMAN'S BURDEN

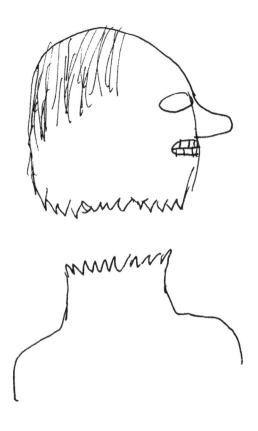

ADVERTISMENT

FOR CLOTHING

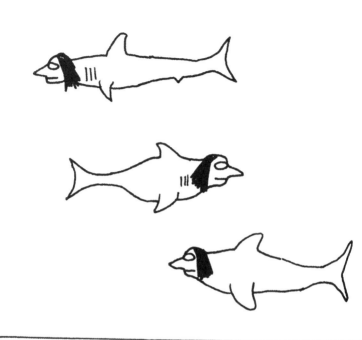

THE SHARK IS A FISH
BUT THE DOLPHIN IS NOT A
FISH IT IS A KIND OF MAN

IN THE CLASSROOM:

PUPIL : PLEASE SIR, WILL
THERE BE A NUCLEAR
WAR ?

TEACHER : YES

PUPIL : PLEASE SIR, WHAT
WILL HAPPEN ?

TEACHER : WE WILL ALL DIE

(SOUND OF GIANT REPTILES
BELCHING)

I'M NOT GOING TO PICK UP
THE RUBBISH BECAUSE IT'S NOT
MY JOB. BESIDES, I LIKE THE
RUBBISH. I HAVE CHOSEN TO MAKE
MY HOME AMONGST THE RUBBISH.

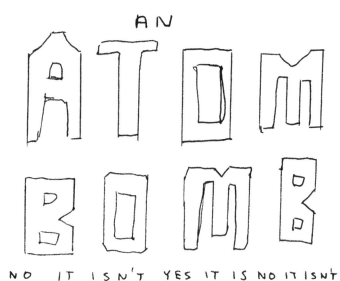

AN ATOM BOMB

NO IT ISN'T YES IT IS NO IT ISN'T
YES IT IS NO IT ISN'T YES IT IS
NO IT ISN'T YES IT IS NO IT ISN'T
YES IT IS NO IT ISN'T YES IT IS
NO IT ISN'T YES IT IS NO IT ISN'T
YES IT IS NO IT ISN'T YES IT IS
NO IT ISN'T YES IT IS NO IT ISN'T
YES IT IS NO IT ISN'T YES IT IS
NO IT ISN'T YES IT IS NO IT ISN'T
YES IT IS NO IT ISN'T YES IT IS
NO IT ISN'T YES IT IS NO IT ISN'T
YES IT IS NO IT ISN'T YES IT IS
NO IT ISN'T YES IT IS NO IT ISN'T
YES IT IS NO IT ISN'T YES IT IS

CREAM OF FILTH:

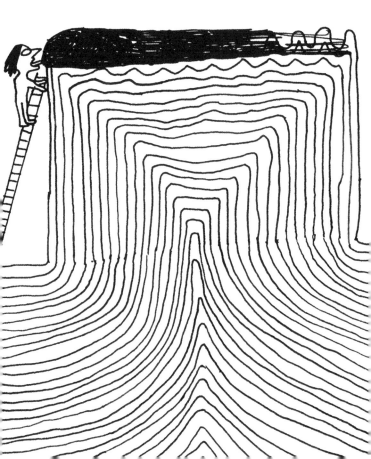

HUNTING

NO HUNTER WOULD HUNT
WHAT YOU HUNT FOR
A TRUE HUNTER WOULD
KNOW SUCH THINGS ARE
NOT ██ ██ TO BE
HUNTED

THE CANDLE

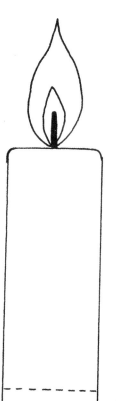

WHEN IT
BURNS DOWN
TO HERE WE'RE
ALL FUCKED

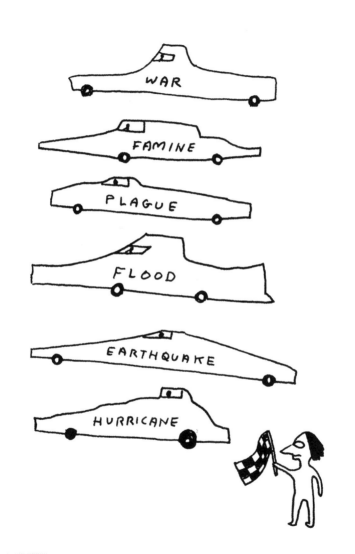

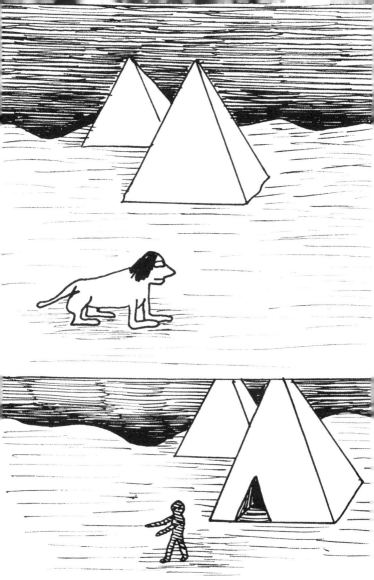

THERE

WILL

COME A

TIME WHEN

THINGS THAT AREN'T ACCEPTABLE
 WILL BECOME ACCEPTABLE

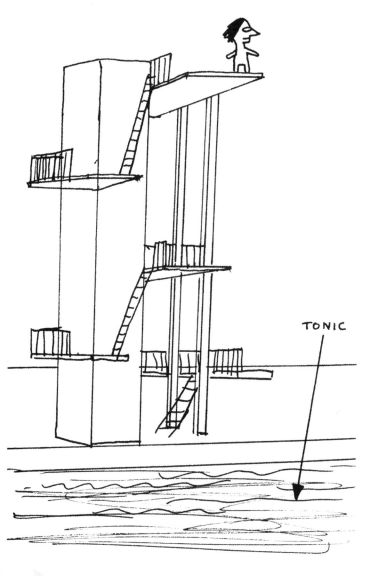

TONIC

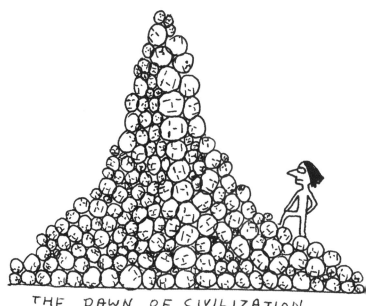

THE DAWN OF CIVILIZATION
MET WITH SOME RESISTANCE
BUT IT WAS SOON SORTED-OUT

GRASS

POT

WINDOW SILL

THERE IS VERY LITTLE IN THIS
LIFE THAT MAKES SENSE TO ME

DESPITE REPEATED WARNINGS YOU BECOME A FRIEND TO THE DEFECTIVE AND THE DAMNED AND IN DUE COURSE YOU THUS ~~BECOME~~ FALL PREY TO PESTILETIAL FORCES. YOU REMOVE YOURSELF FROM SOCIETY AND WHEN YOU ARE EVENTUALLY VISITED BY THE SOCIAL SERVICES YOUR ABODE RESEMBLES THE DEN OF A PSYCHOPATH. I AM SHOCKED TO ~~LEARN THAT~~ YOU WERE DRESSED LIKE ME AND WITH A SIMILAR HAIRSTYLE AND WERE LISTENING TO A CLASH RECORD THAT YOU BORROWED FROM ME AGES AGO AND NEVER GAVE BACK.

ALMOST BUT
NOT QUITE
COMPARA
COMRENS
CO HEARN
CONTRITTN
COEHEEREENT
COMPRINDSIBL
COHANDLABLE
CORHEARAND
COMPRANDS
C

AVAILABLE IN BRAILLE,
LARGE PRINT AND AUDIOTAPE

HOW THE ALIENS SEE US:

HOW ~~WE~~ WE ARE:

PLEASE TRY NOT TO CUT MY
HEAD OFF ████████ AGAIN

THE WORSHIP OF OBJECTS IS
NOW CONSIDERED PRIMITIVE
BY PEOPLE LIKE ME. WE
USED TO WORSHIP OBJECTS
BUT NOW WE WORSHIP IDEAS.

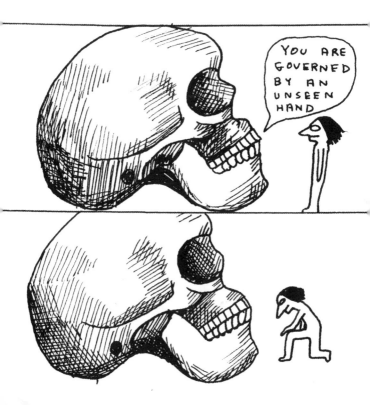

PULLEY ROPES REPLACED £30

WHOLE PULLEYS SUPPLIED AND INSTALLED £125

THE TREE SPRITE

ALWAYS ATTENDS THE FELLINGS

SCIENTIST
DISCOVERS
CURE FOR
BOREDOM

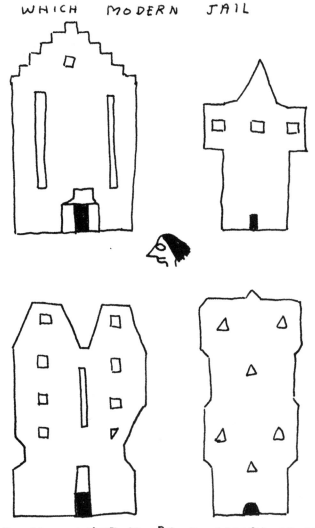

PEANUT IN THE DISTANCE

PEANUT UP CLOSE

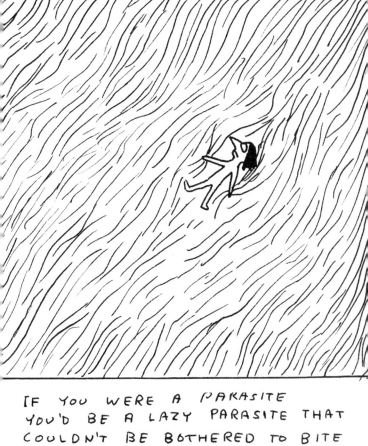

IF YOU WERE A PARASITE
YOU'D BE A LAZY PARASITE THAT
COULDN'T BE BOTHERED TO BITE
IT'S HOST. YOU'D JUST CLING ON
TO THE HOST'S FUR AND NOT DO
ANYTHING. IN FACT TECHNICALLY
YOU WOULD NOT BE A PARASITE,
YOU'D BE PIECE OF LIVING DIRT.

THE CHAMBERS OF THE STOMACH
FILLED WITH GRASS

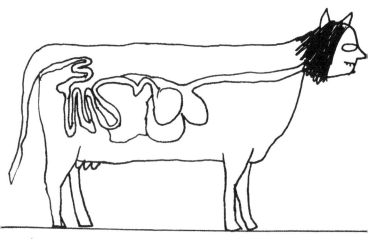

GRASS FROM OUR GARDEN
GRASS FROM THE VERGE ON OUR STREET
GRASS FROM NEXT DOOR'S GARDEN
GRASS FROM VARIOUS OTHER GARDENS

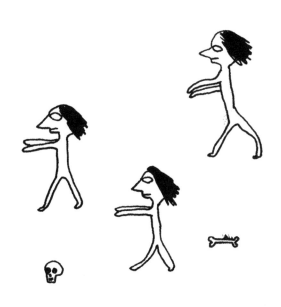

I HAVE NOTICED THAT THERE ARE
NO ZOMBIES IN CHILDRENS'
LITERATURE AND VERY LITTLE
KILLING AND TORTURE.

A
WELDING
MASK

AND
STILL YOUR HEART BEATS.....

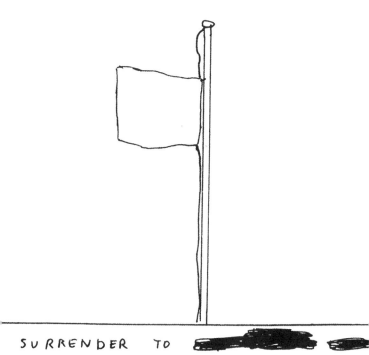

SURRENDER TO

YOUR DESTINY

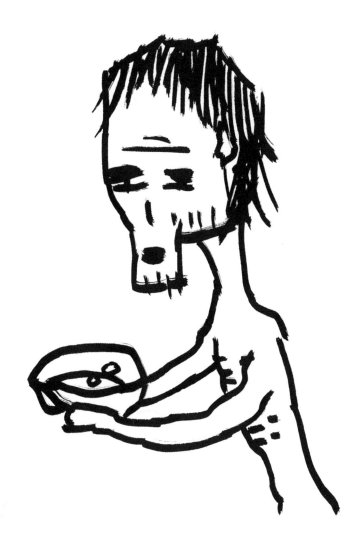

MEET ME AT THE HORIZON